THE LIFE AND WORKS OF
TURNER
Clarence Jones

A Compilation of Works from the
BRIDGEMAN ART LIBRARY

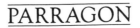

Turner

This edition first published in Great Britain in 1994
by Parragon Book Service Limited

© 1994 Parragon Book Service Limited

ISBN 1 85813 516 8

Printed in Italy

Editorial Director: Lesley McOwan
Designer: Robert Mathias
Production Director: David Manson

Joseph Turner 1775-1851

QUEEN VICTORIA IS SAID not to have bestowed a knighthood on J.M.W. Turner, as she did on other, lesser painters like Alexander Calcott, because she thought he was mad. This is not entirely unlikely. Turner had a breadth and depth of mind which made his later paintings difficult of access, even for his closest admirers, and his behaviour often had the eccentricity of those whose attention is focused on less prosaic things than good manners. His early work was easily acceptable and within the conventions of the Royal Academy, so that he made rapid progress under the eye of Sir Joshua Reynolds, whose theories on poetic painting and Platonic ideal forms appealed to young Turner. With maturity, Turner carried the notion of ideal forms further into the realm of the universal truths behind reality, believing that appearances are only arbitrary images concealing deeper absolutes.

These ideas motivated much of his early painting which, though kept within the conventions of current technique, concealed symbols which revealed Turner's real thoughts about the universe. His men struggling against the elements are anti-heroes, quite different from the Renaissance concept embodied in Leonardo's man encompassing the universe. Turner's lighthouses illuminating the way to safety are strewn with wrecks; Turner's Sybil is giving the golden bough which confers immortality, not to Aeneas, but to a group of dancing maidens who are ignoring the gift. Turner's message – that man is unaware and little concerned with his destiny – led his work into the deep waters of metaphysics, with paint becoming a medium, not for depicting scenery but for describing the unseen forces that govern man's destiny.

Joseph Mallord William Turner was born in Maiden Lane, London in 1775. His father was a wigmaker who became a hairdresser when

wigs went out of fashion and later helped his son to prepare and frame canvases. His mother was mentally unstable and his sister died young. The domestic problems of the Turner family led to young Turner's being sent to stay with his uncle at Brentford. From here, he managed to get into the Royal Academy school, where he was soon being noticed for the quality of his work and for his dedication. He spent three years making copies of the work of F.R. Cozens, which was a good discipline, and listening to the ideas of Joshua Reynolds, which opened his mind. He had little general education when he set off on his first trips in England and Wales, armed with the sketch books that would become an essential part of his travelling impedimenta all through his life.

It was from an early trip to Wales that we have the first description of Turner as a 'plain uninteresting youth in manners and appearance . . . careless and slovenly in dress...not particular as to the colour of his coat . . .' Later, Constable was to describe him as 'uncouth but with a wonderful range of mind.'

Turner was eighteen at the time of his first trips; soon after, he met Girtin and began filling in his drawings with colour and also copying architects' plans. This discipline served him well and by 1790 he had already exhibited a watercolour at the Royal Academy. In 1793 he won the Society of Arts' Greater Silver Pallet for landscape drawing. In 1799 he was elected an associate Royal Academician and a full member in 1802.

It was about this time that he began a relationship with his housekeeper's niece, who became his mistress and bore him two daughters, Georgina and Evelina. Little is known about Turner's menage or about the fate of his mistress, whom he did not marry; in his will he left a considerable legacy to the housekeeper, Mrs Danby.

In 1805, Turner held an exhibition of his paintings in his own gallery in London. Soon after he became Professor of Perspective at the Royal Academy.

Turner's artistic hero had always been the French painter, Claude, and in 1820 he visited Paris to see his work, also discovering Titian

and Poussin. There now began a series of tours in search of suitable material for watercolours and oil paintings which engravers could reproduce and sell in large quantities. Among the series which grew out of these tours were 'Picturesque Views of England and Wales', 'The South Coast of England' and 'The Rivers of France'. By now, Turner had become an established painter, travelling abroad almost every year making thousands of sketches, some of which he turned into watercolours or oil paintings on his return home. He first visited Venice in 1817, and made two subsequent visits to the city. The atmosphere of Venice liberated his technique which became more and more fluid and less attached to the actual scenes before him. This brought him a good deal of criticism but also the support of men like John Ruskin who published an appraisal of Turner's work in his five-volume *Modern painters*.

Turner himself was becoming more and more of a recluse, to the extent that when in 1833 he began to live with a lady called Mrs Booth, he called himself Admiral Booth. According to David Roberts, the engraver and draughtsman, Turner was a miser, who never gave Mrs Booth any financial support, and a hoarder, collecting all the engravings of his work and storing them away.

At the end of his life Turner was a disappointed man, despite his great achievements. The approach of old age and the end of his creative powers saddened him. Perhaps the lack of comprehension of the significance of what he was doing and the lack of official recognition depressed him too. He was certainly eccentric but not so eccentric that he forgot his fellow artists in distress, for whom he left a fortune to build a charitable foundation, or the nation, to whom he left all his work on condition that it was kept in a special Turner gallery. The foundation was never built because the will was contested and dismissed on a technical point of law. The gallery, in a special wing of the Tate Gallery in London, came into being in 1987 thanks to the generosity of Sir Charles Clore and the efforts of the Turner Society. It is a fitting tribute to an artist considered today to be one of the finest landscape and seascape painters the world has known.

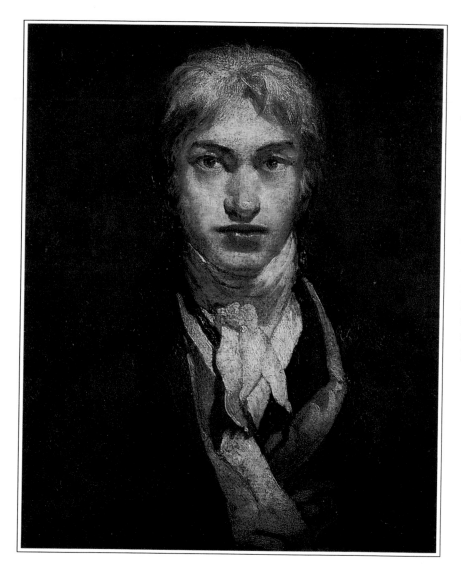

◁ **Self-portrait** c.1798

Oil on canvas

THE HANDSOME YOUNG MAN is
Joseph Turner at the age of
about 23. The painting is one
of only two known self-
portraits of one of the world's
greatest artists. The skill and
confidence with which the
paint is handled communicates
instantly that here is an artist
of extraordinary stature, a
unique personality in the
world of creative art. Like
most geniuses, Turner was a
man driven by a powerful
conviction about the world
and his way of expressing it in
paint.

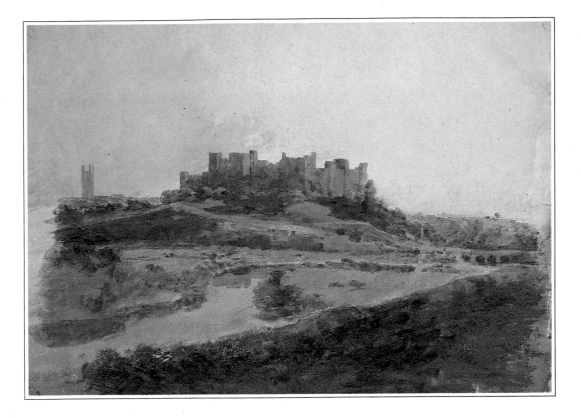

△ **Ludlow Castle** 1798

Watercolour

TURNER MADE EXTENSIVE tours of the west of England and Wales, painting a great many oils and watercolours. From his earliest works, his style of painting tended to dramatize the subject of a picture, making mountains, castles, crags larger than life and often wrapped in stormy skies. This approach upset other artists of Turner's time, such as Sir George Beaumont, art connoisseur and painter, who was regarded as an authority on landscape. It is possible, of course, that Sir George was a little envious of the freedom and confidence with which the young Turner worked. In this picture of Ludlow Castle Turner has made the castle more imposing than in reality.

◁ **South View of Salisbury Cathedral** 1802

Watercolour

IN 1802, the year that Turner was elected a full member of the Royal Academy, his painting and drawing were within the accepted conventions of the art of his time and he had little difficulty in finding supporters. Having spent three years copying J.R. Cozens, he had laid a solid foundation for his working technique, which he strengthened by assiduous sketching of landscape and buildings. This view of Salisbury was done some years before Constable's more famous works, and is a more conventional treatment.

▽ **Boulevard des Italiennes** c.1802

Oil on canvas

AFTER THE PEACE of Amiens Paris became a popular destination for British travellers, long denied the pleasures of the Continent and now eager to see how their erstwhile enemies were getting on. Many comments were critical, as they had ever been, but the English, on the whole, enjoyed their stay. Turner visited Paris in 1802 on his way home from Switzerland. He was bowled over by the Louvre, where Napoleon had deposited most of the artistic loot he had picked up on his military expeditions in Europe. Turner filled notebooks with his sketches and notes of paintings in the great museum. When he was not at the Louvre Turner enjoyed the open-air life of the streets of Paris and recorded the Boulevard des Italiennes, which would later attract Monet and Renoir.

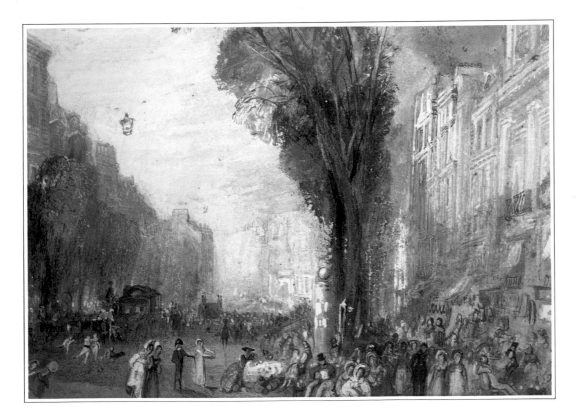

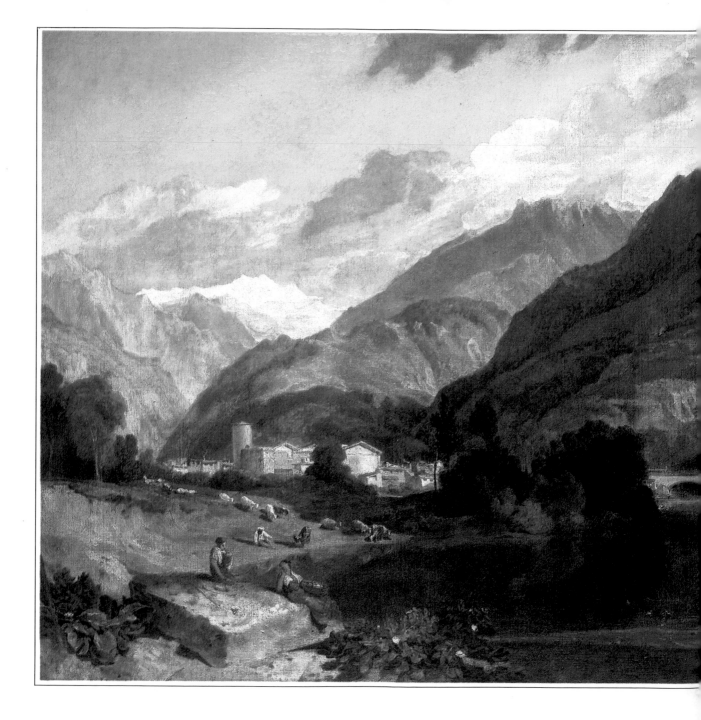

◁ **Bonnevilie, Savoy with Mont Blanc** 1802

Oil on canvas

TURNER MADE HIS FIRST visit to Switzerland in 1802, after the Peace of Amiens with France seemed to promise at least a few years without the hazards of war for English travellers on the Continent.

He travelled down to the Val d'Aosta into Italy and saw Mont Blanc for the first time. He was duly impressed, making a number of rapid studies as was his wont with a view to turning them into paintings later. The Bonneville paintings, which included one that he entitled *Chateaux de St Michael Bonneville,* were much admired by Sir Thomas Lawrence, whose opinion Turner valued.

▷ **Calais Pier, with French Poissards preparing for Sea: an English Packet Arriving** 1803

Oil on canvas

THIS PAINTING, inspired by Turner's first crossing of the English Channel, was exhibited at the Royal Academy in 1803, the year after Turner was elected a full Academician. It was no doubt intended as a *tour de force* as well as a topical allusion to the political situation with France. The Peace of Amiens had made Turner's trip possible but here he shows an English packet, arriving in Calais, being almost run down by a French boat which is evidently not being well handled by what Turner calls the 'poissards' (from the French for fishwives) who are preparing to go to sea. The superb representation of the sea is a foretaste of many Turner seascapes to come.

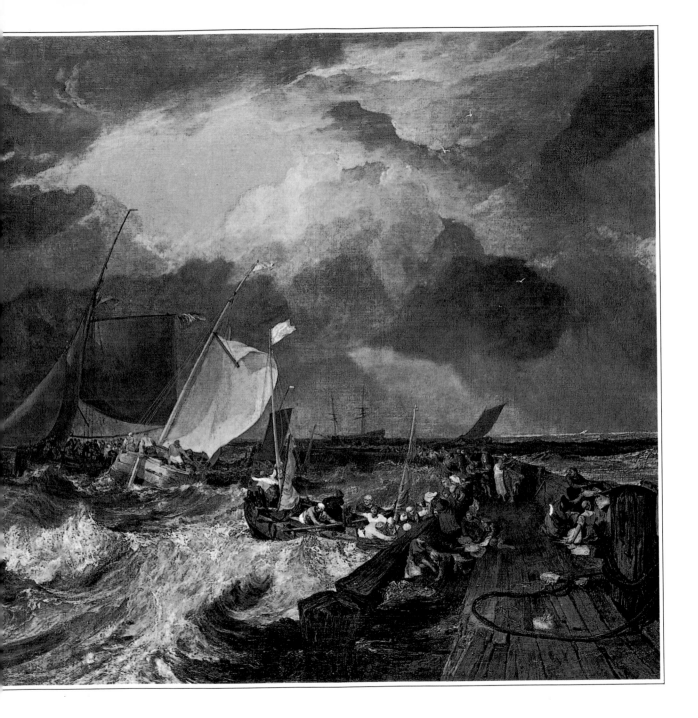

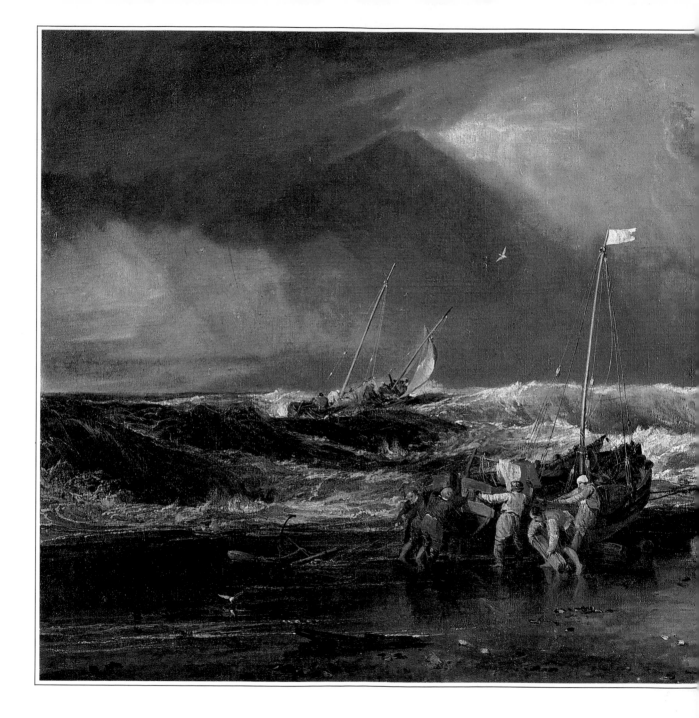

◁ Fishermen upon a Lee Shore 1803-4

Oil on canvas

TURNER WAS ABOUT 28 years old and had just been elected a member of the Royal Academy when he painted this picture. It was sold almost immediately with a companion piece to Samuel Dobree who re-sold it to Lord Delamere on whose death the pair of pictures fetched £2500, a considerable sum for those times. The painting shows Turner's early mastery of seascapes and his high powers of observation and visual memory in the details of fishermen pulling their boat ashore and the fish lying on the beach.

▷ **Shipwreck** 1805

Oil on canvas

PEOPLE STRUGGLING in the grip of powerful forces beyond their control was a recurrent theme in Turner's work. In this painting he has left a great deal of space around the central action to emphasise the vastness of the universe in which humans fight to survive. Turner was a master of the seascape at an early age and his knowledge of the movement of the ocean when disturbed by the forces of wind and tide enabled him to paint impressive storm scenes. The gist of Turner's picture seems to be that while everyone is a victim of destructive forces, something in the human spirit, represented by the fishermen on the right, reaches out to give help to others.

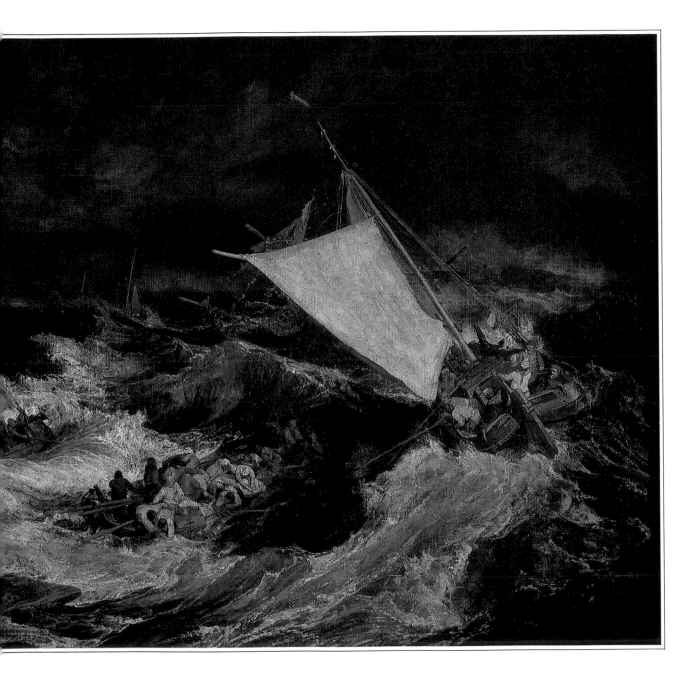

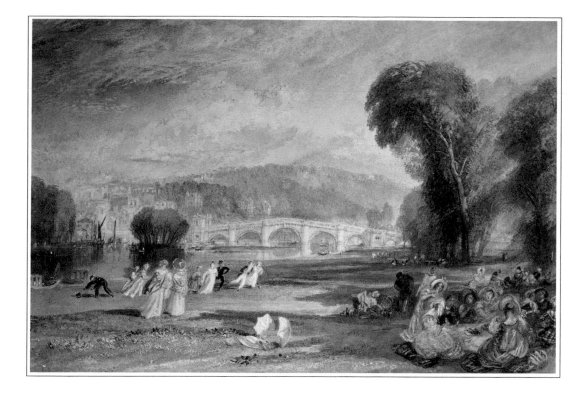

△ **Richmond Hill** 1808

Watercolour

TURNER HAD IMMENSE ease in handling watercolours and developed a technique by which he laid in the main areas of colour with broad washes and then dipped his paper into tanks of water, letting the colours run freely. After this he let the paper dry and added more colour, putting in the drawing with a fine brush. This method of painting enabled Turner to work fast on several paintings simultaneously. In this view of Richmond Hill Turner had not yet arrived at the audacious use of colour of his later paintings but he was certainly using the medium with great fluidity.

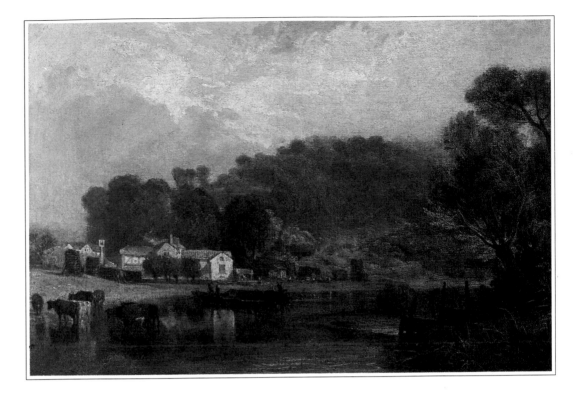

△ **Cliveden on the Thames** c.1808

Watercolour

CLIVEDEN LIES near Maidenhead on an escarpment above the Thames and was once the seat of the second Duke of Buckingham, son of Charles I's favourite. The house burned down in 1795 and was not rebuilt until 1824, which may explain why Turner chose to paint a riverside inn along the Thames rather than the property itself. He did, however, include the hanging woods which grow on the steep sides of the escarpment leading up to the plateau on which the house stood, and which are still a major feature of Cliveden today. Turner made several paintings of the Maidenhead area, including the famous picture of a train crossing Brunel's bridge, *Rain, Steam and Speed – The Great Western Railway* (pages 70-71).

▽ **Windsor Castle** 1808

Watercolour

TURNER MADE A GREAT many studies in Windsor and the surrounding countryside, filling at least one sketchbook and including the area in others. Windsor Castle, which began life as a hunting lodge for William the Conqueror, was an essential subject for Turner in his quest for picturesque views which would have popular appeal. The castle, poised on an escarpment above the Thames, is seen here from the Eton side, the site of Eton College and its chapel. In Turner's time the riverside was swampy and only used for pasture, but this gave Turner the kind of foreground which he often used, horses and boatmen giving life to an otherwise empty landscape.

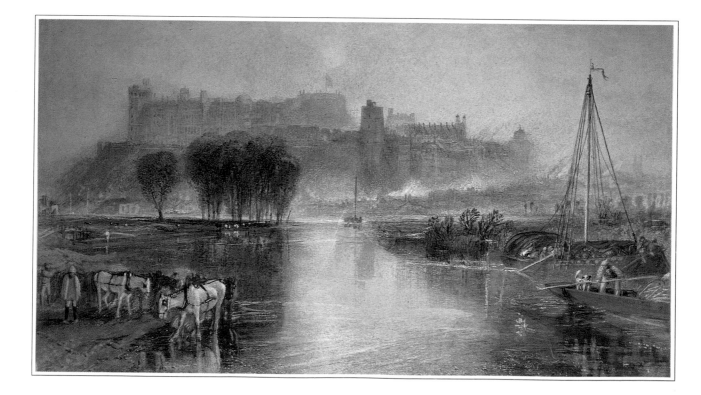

▽ **Snow Storm: Hannibal and his Army Crossing the Alps** 1812

Oil on canvas

THE IDEA FOR AN EPIC painting including a thunderstorm came to Turner one day at Farnley Hall in Yorkshire, the home of his patron Walter Fawkes. As the storm broke Turner began to sketch the clouds and lightning on a piece of paper, saying to his patron, 'In two years you will see this again and call it Hannibal crossing the Alps.' As often happens with painters, an idea which had been dormant in Turner's mind had suddenly become converted into a complete image as the result of a fortuitous event. The great painting (it measures 145 x 236.5cm/57 x 93in) was shown at the Royal Academy exhibition of 1812 and was one of the highlights of the event. Its title in the exhibition catalogue was accompanied by some of Turner's own verses, hinting at the vanity of territorial expansion (a dig at Napoleon's France?).

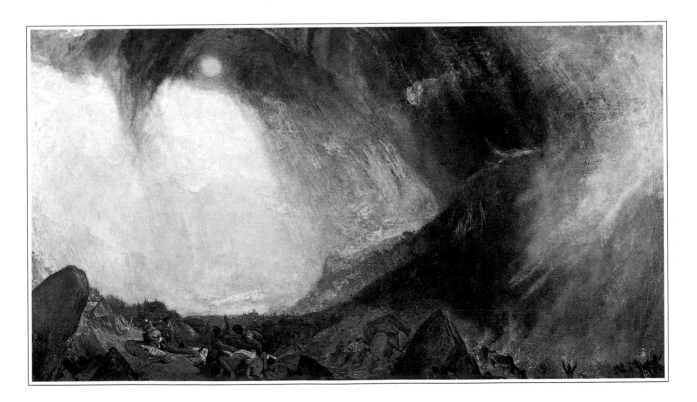

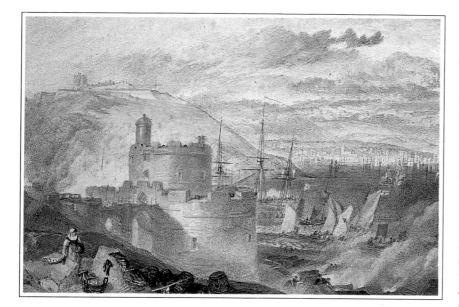

△ **Falmouth Harbour** 1812

Watercolour

FALMOUTH, IN CORNWALL, was a naval harbour and a first port of call for ships that had crossed the Atlantic; the Falmouth packets were famous for their rivalry in the speed of their passage and for their tough, disciplinarian captains. Turner visited the west of England in 1811, gathering material for a series of views of the 'South Coast'. His first notes of Falmouth were made in the sketch book of his west of England trip and the paintings came later. With his usual audacity in reforming the scene he saw to suit the demands of his composition, Turner changed the height of the hill on which Pendennis Castle stands and placed Falmouth town on the east instead of the west bank of the Fal estuary. He also moved St. Mawes castle from its actual position on the east bank to the foreground on the west side. The figures in the foreground give the picture an extra liveliness, making it more than a simple topographical scene.

▷ **Tintagel Castle, Cornwall** 1815

Watercolour

DESPITE HIS PRODIGIOUS artistic gifts, Turner was not an aesthete or an intellectual, and set about his paintings in a practical, businesslike way to provide the public with the kind of paintings it wanted. To do so, he early on set himself to illustrate popular themes and places which engravers could turn into prints for sale to a wider market. The ports of Britain was one such theme, which he began to tackle after his first visit to the West Country in 1811. At Tintagel he found the sort of picturesque scenery which the public liked, backed by the fascinating legends of King Arthur and his knights.

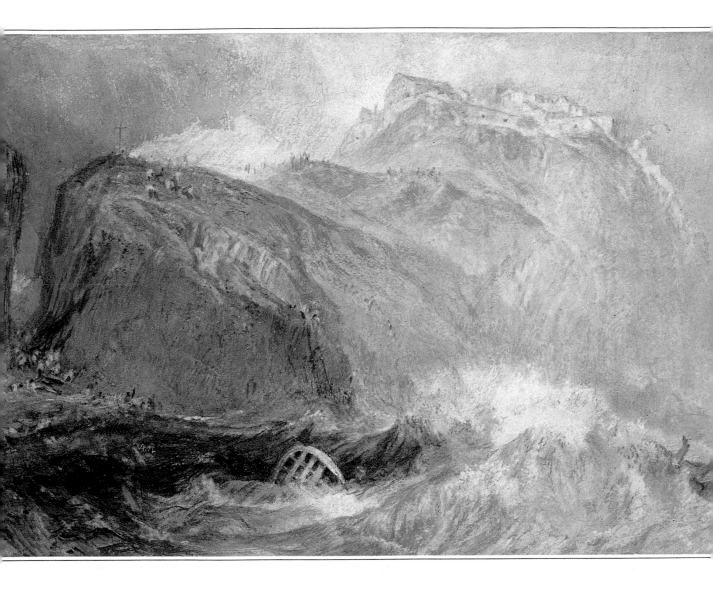

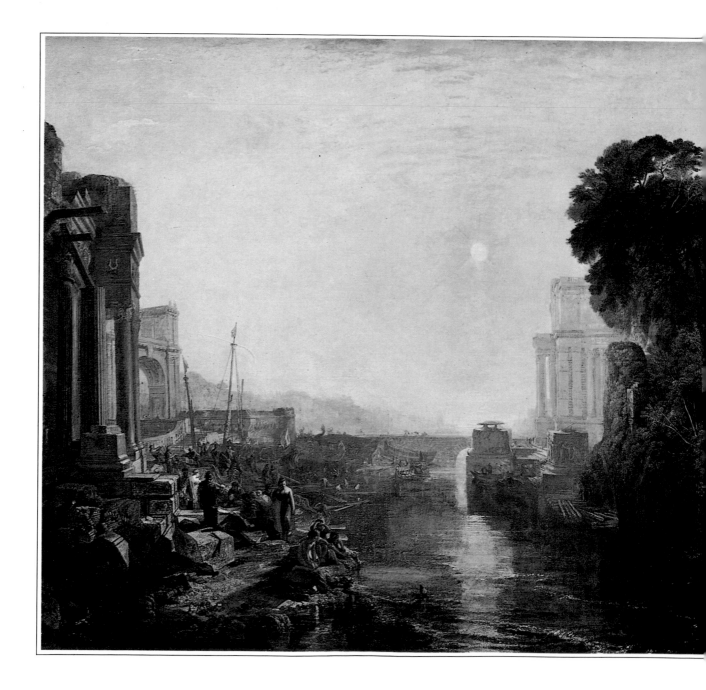

◁ **Dido Building Carthage** 1815

Oil on canvas

DIDO, QUEEN OF TYRE, escaped to Libya after her husband Sychaeus was murdered and there she founded the city of Carthage. In this painting there is much evidence of the influence of Claude Lorrain, the French painter, on Turner. There are classical buildings along the river and the sun's reflection in the water, as in Claude's sea port scenes, though Turner's vision is in a more conventional academic style. The painting was acclaimed by the Royal Academy exhibition of 1815. Two years later, Turner showed a companion piece, *The Decline of the Carthaginian Empire*. Turner thought *Dido Building Carthage* was one of his great paintings and left it in his will to the National Gallery, on condition that it was hung beside Claude's painting *Seaport*.

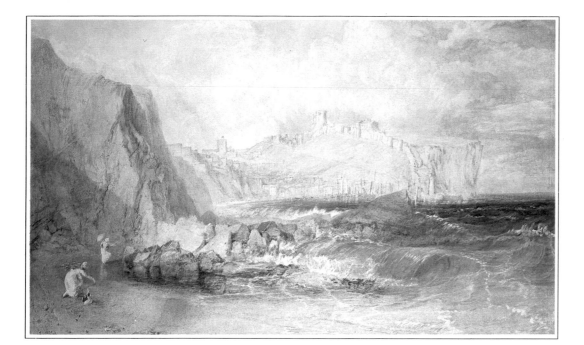

△ **Scarborough** 1820s

Watercolour

The seaside as a holiday destination did not make its mark until the mid-18th century when an enterprising doctor called Richard Russell began to promote the idea that sea-water was good for the health. Scarborough had the good fortune to possess plenty of it and a mineral spring as well, so it soon became a popular seaside spa; even the Brontës stayed there. In his painting, Turner suggests the holiday aspects of Scarborough by including two young ladies, one of whom is paddling and the other is poking at sea creatures washed up by the tide with her parasol.

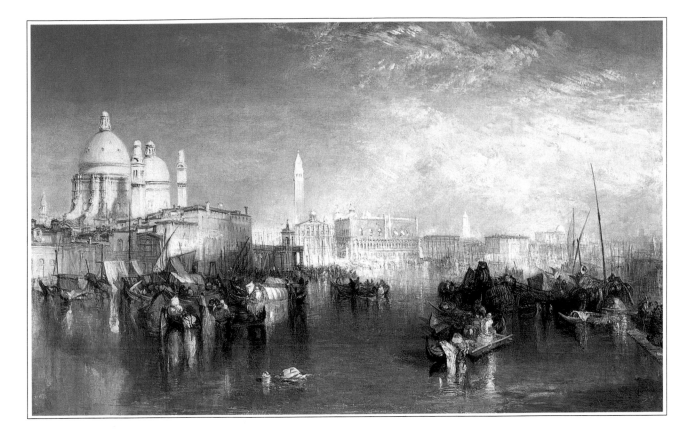

△ **Venice** c.1819

Oil on canvas

TURNER'S FIRST VIEWS of Venice, made during a tour in 1819, were very different from the freely handled watercolours of his 1840 visit. His first paintings, such as this one, were evidently conceived as exhibition pictures and have the finished detail demanded by buyers at the Royal Academy shows. Here, all the attractions of Venice are laid out clearly, à la Canaletto, with the marble dome of Santa Maria della Salute gleaming in the sunshine, the Campanile in St Mark's Square rising like a skyscraper into the blue sky and the Doge's Palace set at the edge of the lagoon on which boats of every description make an exotic floating market.

▽ Venice: San Giorgio Maggiore c.1819

Watercolour

THE CHURCH of San Giorgio Maggiore floats in the middle of the Venetian lagoon like a great ship, its campanile rising above the church, built by Antonio Palladio in 1565. Turner made several paintings and drawings of the church on his various visits to Venice.

The lagoon attracted Turner more than any other part of Venice. Its sense of the infinity of sea and sky and the luminosity of its atmosphere brought out in him his sense of the universality which he sought in the actual scene before him. This concept, which he had first acquired from Reynolds's ideas on poetic painting, persuaded him more and more that painting should concern itself not with the arbitrary experiences of the senses but with fundamental and metaphysical truths.

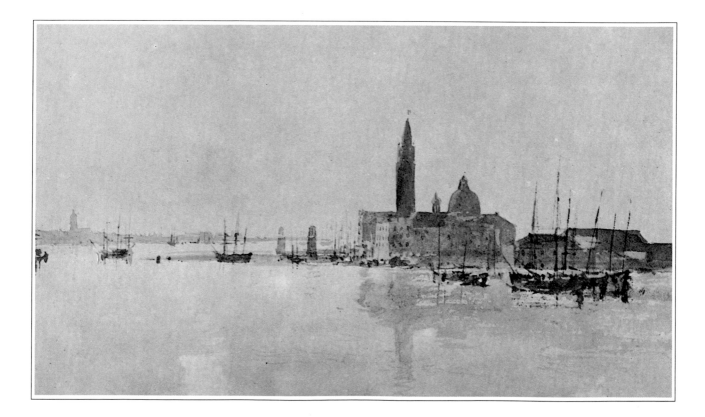

△ **Hastings from the Sea** 1818

Watercolour

TURNER FILLED AT LEAST one sketchbook with views of Hastings. No doubt he had in mind the south coast town's suitability for inclusion in the various series of engravings for which he had been commissioned to provide the raw material in the form of watercolour drawings. While this is a calmer scene than many of Turner's coastal views – rough sea added drama to many a view – a stiff breeze is clearly indicated by the plume of smoke in the left background. The picture, which has been called erroneously *Hastings Deep-sea Fishing*, contains an interesting variety of craft which confirm how well Turner knew his maritime subject. On the left is a cutter and a fishing smack and in the centre a yawl with its sails coming down and a fisherman reaching out with a grappling hook to tie the vessel to a buoy; behind the yawl is a hoy bearing down with its sails filled out as it tacks and on the right is another smack and a brig at anchor.

Portsmouth 1820s

Watercolour

▷ *Overleaf pages 32-33*

In other pictures of Portsmouth Turner emphasized the naval role of the great English seaport, with ships of the line, cutters and other craft much in evidence. Here, by contrast, Turner has depicted a more peaceful scene, showing the harbours of Portsmouth, Langstone and Chichester, and the Solent, the channel between Portsmouth and the Isle of Wight, calm and quiet. The shepherd on Portisdown Hill, which overlooks Portsmouth, is a reminder of England's dependence on the wool trade before the nation's navy and merchant shipping began to establish overseas trade.

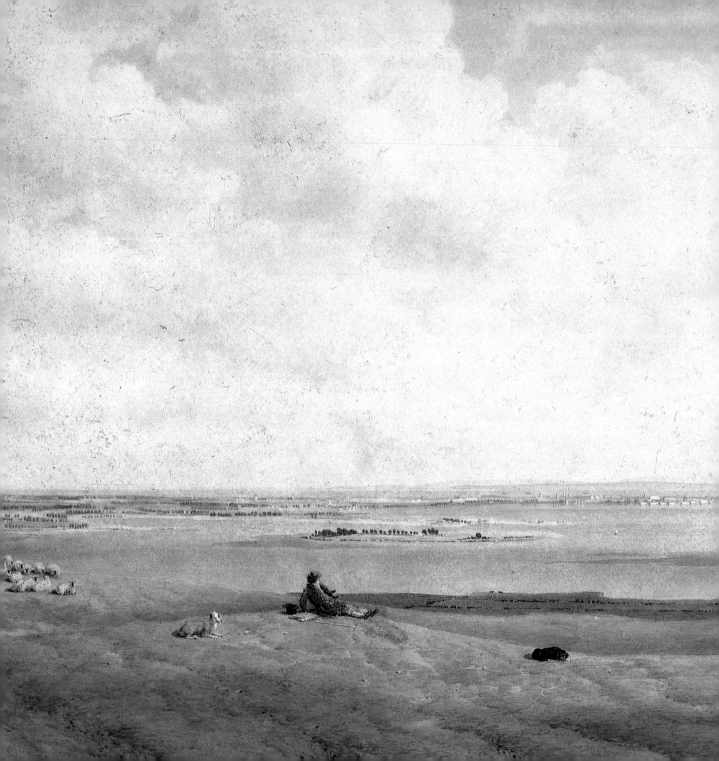

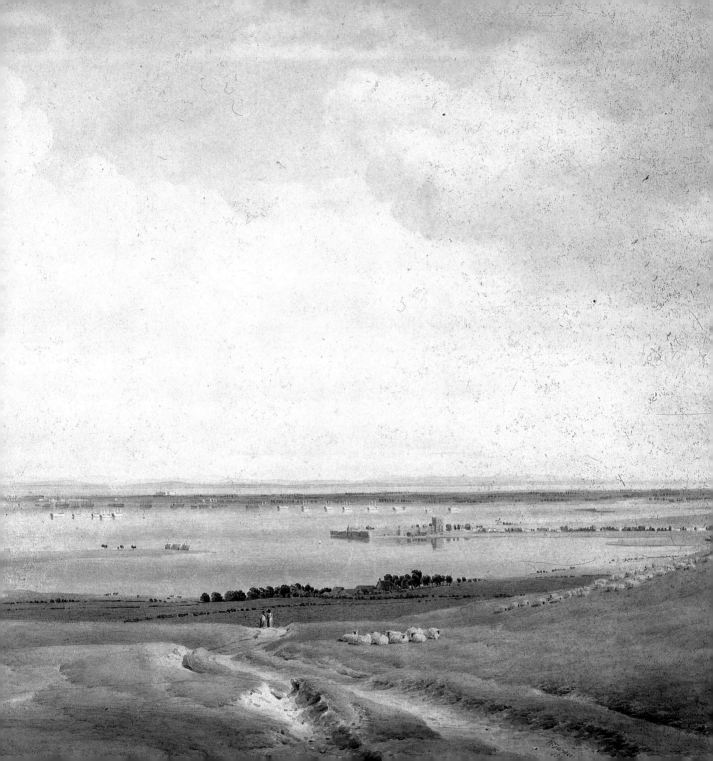

△ **Holy Island, Northumberland** c.1820

Watercolour

HOLY ISLAND, or Lindisfarne, lies off the Northumberland coast and is famed as the home of Saxon priests who created a centre of Christian learning during the so-called Dark Ages. The island, protected by quicksands, was accessible in Turner's time, as it is now, by a causeway at low tide. The painter was, no doubt, attracted to the island by its atmosphere and by the fact that it was a place of pilgrimage, making it a subject which might attract buyers. Not unexpectedly, Turner moved the elements of the scene to suit his composition, placing the castle to one side so it would not distract from his foreground subject.

△ **Dartmouth, on the River Dart** 1824

Watercolour

TURNER PAINTED various views of Dartmouth, a small fishing port and shipyard on the south coast of Devon which had played a part in the transporting of troops to France during the Hundred Years' War. The port, which lies in the estuary of the River Dart, is guarded by two castles which add a dramatic touch to the steep wooded slopes of the hills bordering the estuary. This was the kind of scene that appealed to Turner's romantic side and he made the most of it in this picture.

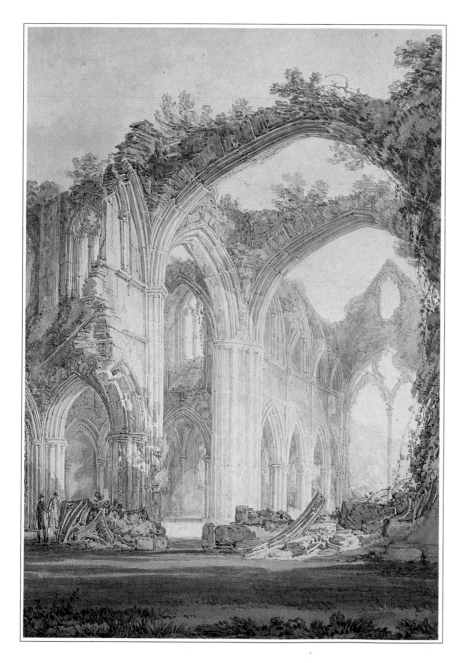

◁ **Tintern Abbey** 1825

Watercolour

THE RUINED ABBEY in the Wye Valley, on the borders of England and Wales, inspired Wordsworth's famous poem in 1798 and, later, this watercolour made from Turner's sketchbook of a visit to Wales. Turner's sketchbooks were a storehouse of ideas for later paintings, though he usually only made a broad note of the landscape, leaving the detail in his memory, to be added after he had laid in the main composition.

▽ **Stonehenge** c.1825-8

Watercolour

ONE OF TURNER'S most important sponsors was the noted antiquarian and authority on ancient British history, Sir Robert Colt Hoare. It was probably Hoare who aroused the artist's interest in the prehistoric monuments of the west of England. This quiet watercolour is one of several views of Stonehenge that Turner did. It appears to have been conceived as a landscape; the monument itself has obviously been added later.

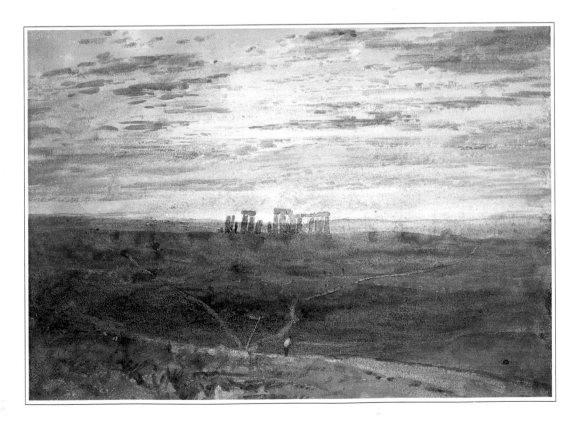

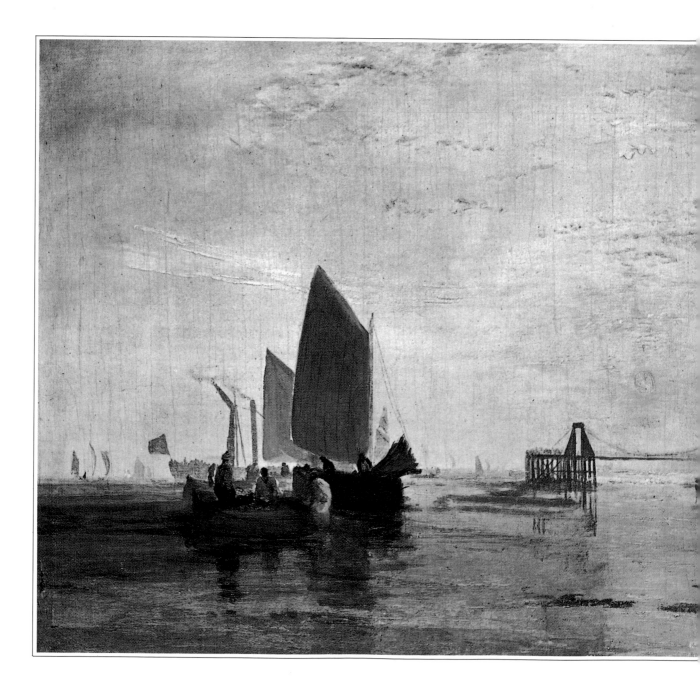

◁ **Old Chain Pier, Brighton** c.1828

Oil on canvas

TURNER DID THIS PAINTING of the Old Chain Pier at Brighton for his patron, George Wyndham, 3rd Earl of Egremont, who had a financial interest in it. The pier was a landing stage for Channel packets and, later, a place for promenading. The pier had been included by Turner's rival, John Constable, in a general view of the beach some years earlier. Turner concentrated on the structure itself, though he later added some details in the foreground. The painting was hung at Petworth House, Lord Egremont's country seat.

▷ **Petworth Park, Tillington Church in the Distance** c.1828

Oil on canvas

GEORGE WYNDHAM, Earl of Egremont, owner of Petworth House in Hampshire, was an enthusiastic collector of paintings and particularly admired the work of Turner, whom he frequently invited to Petworth. Some 116 'Petworth Watercolours' have been credited to Turner, all done around 1830; there were also numerous oil paintings. Turner sold no less than 19 paintings to his patron. After he had done this painting of the park at sunset, Turner added to it considerably, including a few more deer and, perhaps symbolically, Lord Egremont himself, an old man walking his dogs towards the setting sun.

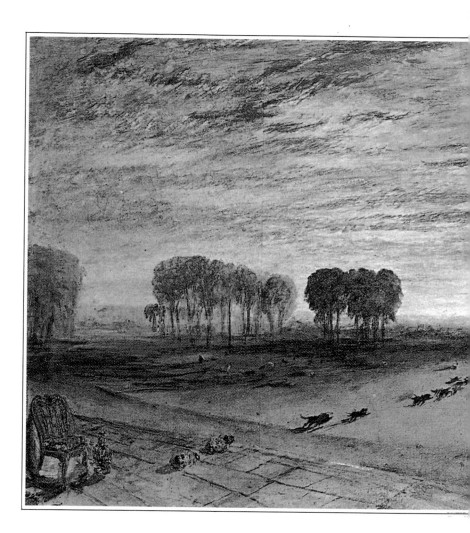

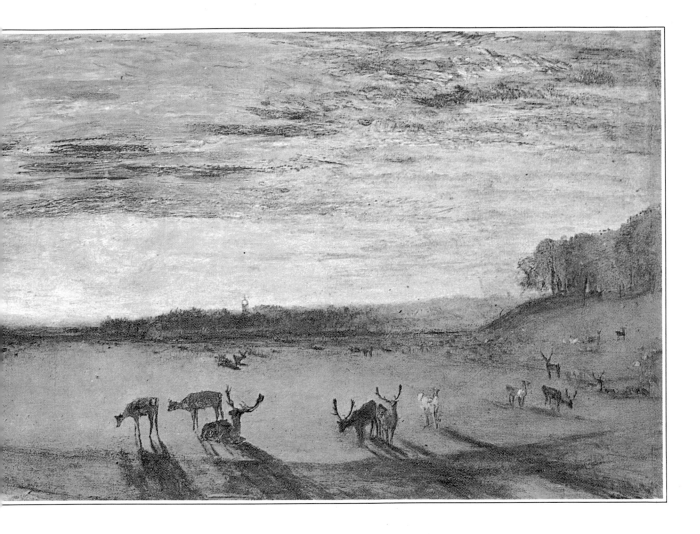

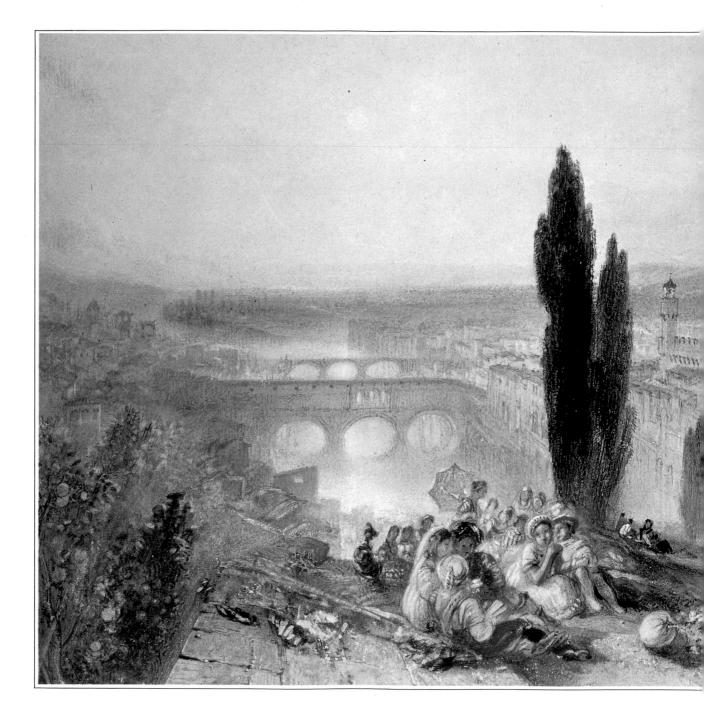

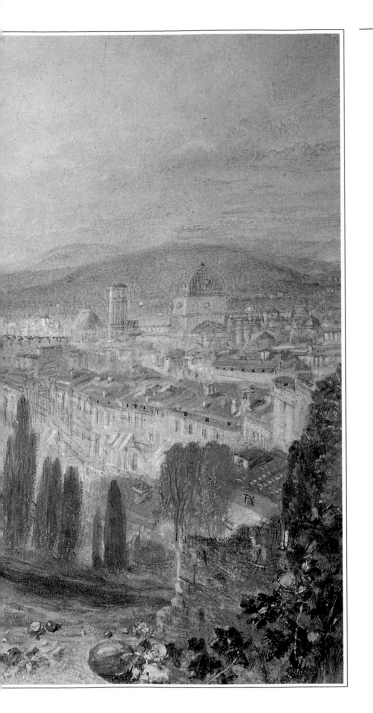

◁ **Florence from San Miniato** 1828

Watercolour

SAN MINIATO stands on a hill above Florence and possesses a jewel-like little church, from the terrace of which Turner recorded this view of the Tuscan city. His main interest was the city but, as in many of his paintings from home and abroad, he has filled the foreground with figures. Behind them the city stretches across the valley of the Arno, its history revealed by its churches and palaces. To the left is the Pontevecchio crossing the river, then the tower of the Ducal palace, the Giotto tower and the Dome of the Cathedral, all important landmarks to Turner who had gone to Italy to study the great Renaissance city.

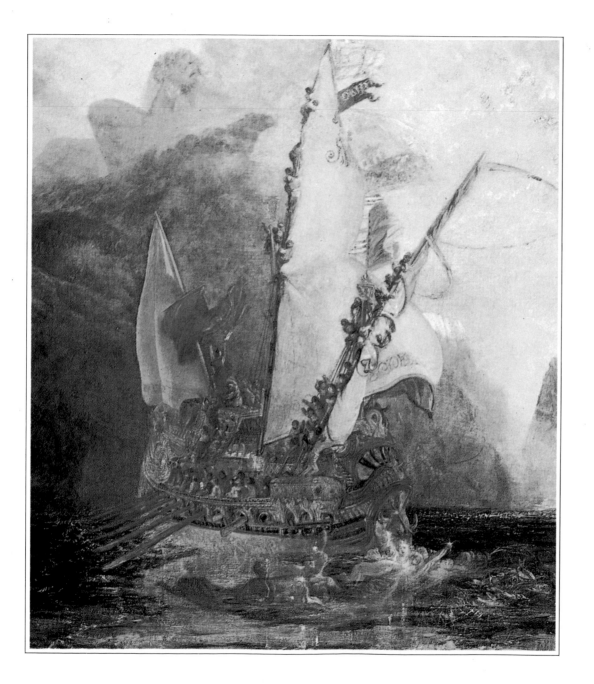

◁ **Ulysses Deriding Polyphemus – Homer's Odyssey** 1829 (detail)

Oil on canvas

ULYSSES AND HIS FRIENDS, sailing home from the Trojan Wars, were captured by the one-eyed giant, the Cyclops (Polyphemus), and escaped by putting out the giant's one eye with a burning stake. Turner depicts the moment when Ulysses makes his escape to his ship, pursued by the furious giant who is seen behind the clouds clutching his eye and shaking his fist. The painting, with its bright primary colours, shocked some of Turner's contemporaries. One critic wrote 'Although the Grecian hero has just put out the eye of the furious Cyclops, that is really no reason why Mr Turner should put out both eyes of us harmless critics.'

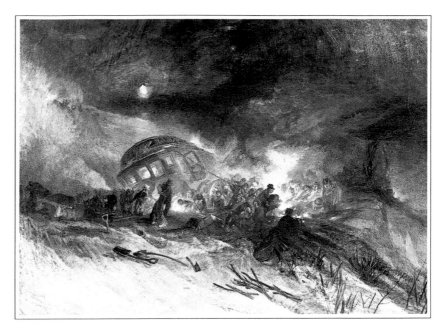

△ **Travellers in a Snowdrift** 1829

Oil on canvas

IT WAS NOT UNUSUAL for coaches (diligences) to get stuck in snowdrifts or to overturn as they negotiated the narrow snow-covered roads over the passes in the Alps. Turner himself had been twice involved in such incidents. Though he painted this scene in the comfort of his studio, he evidently recalled the detail of what had happened: the coach half overturned off the road, the passengers warming their hands at a wood fire and mountain peasants pulling the coach upright and goading oxen to heave it back onto the road. Travel by diligence was the only way to cross the Alps before the Mont Cenis tunnel was built in 1871, thus opening Italy to waves of tourists.

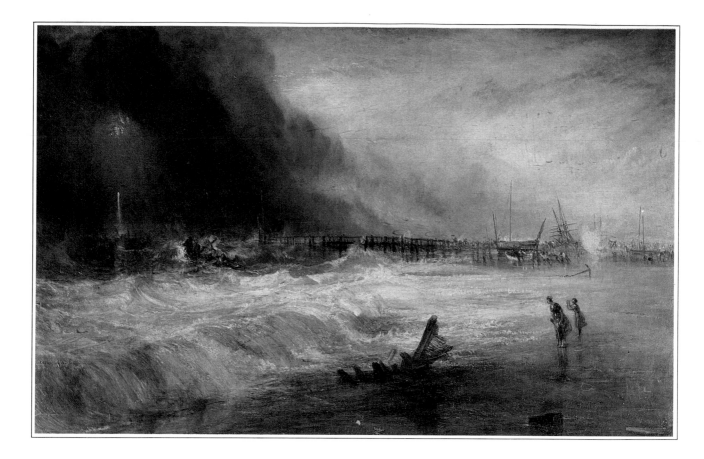

△ Lifeboat and Manby Apparatus Going off to a Stranded Vessel, Making Signal (Blue Lights) of Distress 1831

Oil on canvas

THE DANGERS OF THE SEA were very real ones in Turner's time: shipwrecks were common and many beaches were strewn with the wreckage of vessels that had foundered or had been dashed against the rocks. This picture, originally called *Blue Lights off Great Yarmouth*, was probably commissioned by Captain G.W. Manby of Great Yarmouth, who invented an apparatus for shooting a cable on board foundering vessels by mean of a mortar. Turner's dramatic picture shows the lifeboat beating its way over the waves towards a distress rocket hanging in the dark clouds; on the beach, two women and a child look on anxiously, while the wreckage of another craft lies in the sand.

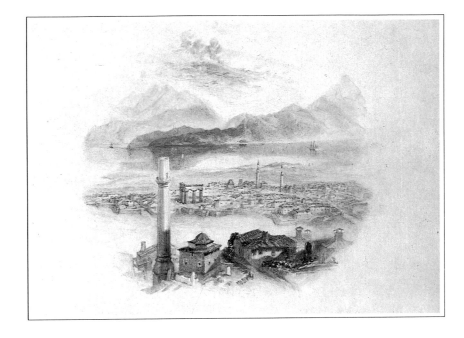

△ **Corinth** c.1831-2

Watercolour

MUCH OF TURNER'S WORK was done for engravers, who would then make prints for sale to a wider public. In 1826 he also began to produce small drawings suitable for book illustrations. These were more clearly drawn than his watercolours, in many of which he aimed at atmospheric effects. The illustrations appeared in a number of books including Rogers' Italy, the Life, Prose Works and Poetical Works of Walter Scott, and others, including Moxon's Byron, for which this picture of Corinth was probably intended. Most of Turner's illustrative work was destroyed after publication.

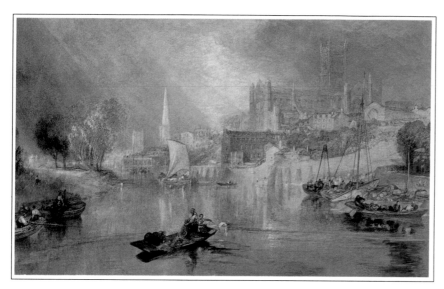

△ **Worcester Cathedral and River Severn** c.1833

Watercolour

IN TURNER'S TIME, England's cathedrals were great landmarks, visible from miles away and important social and religious centres. This is how Turner saw Worcester Cathedral, and he gave it a suitably imposing appearance, dominating the town and the commercial buildings by the river port. With his penchant for the dramatic, Turner also included a thunderstorm (disappearing to the left of the picture) and a watery sky through which the sun's rays illuminate the red sandstone cathedral.

△ **The Golden Bough** 1834

Oil on canvas

TURNER CHOSE LAKE AVERNUS near Naples in Italy as the setting for the legend of the golden bough (from Virgil's Aeneid) because of the lake's

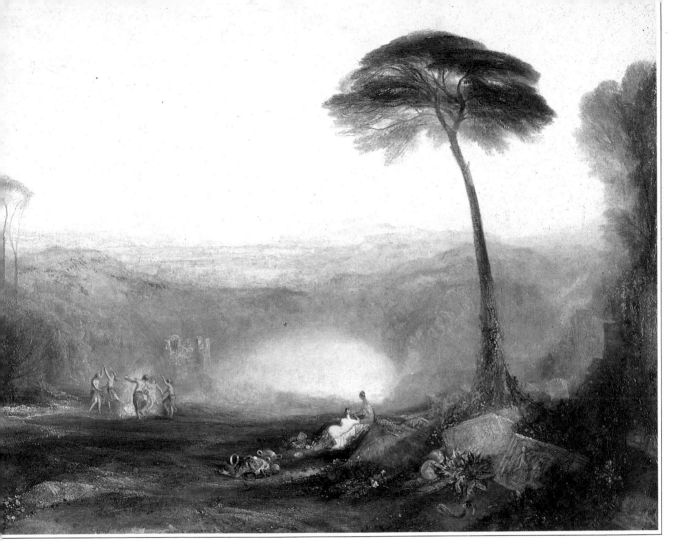

ancient reputation as the entrance to the kingdom of the dead. As one can see from the painting, the lake is an old volcanic crater, with underground vents. In Greek legend the Sibyl gave Aeneas the golden bough he needed to get back from the Underworld where he visited his dead father. In Turner's painting there is no Aeneas; the Sibyl is alone, holding the golden bough high in the air. Is she prophesying the coming of Christ (and therefore eternal life for believers), as some early Christians believed? Or is Turner, in fact, commenting on mankind's indifference to its fate? Certainly, the dancers and nude women in the picture appear to be ignoring the Sibyl and her device for evading death.

▷ **The Burning of the House of Lords and Commons, 12 October 1834** 1835

Watercolour

TURNER PAINTED this dramatic scene from sketches he made at the conflagration and showed an oil painting at the Royal Academy in 1835. Evidently, he had not finished it when he submitted it, for when he arrived on Varnishing Day he took out his paintbox and proceeded to work on it. According to an eyewitness, Turner's painting was a 'mere dab of several colours' and 'without form or void'. After three hours' work Turner covered the whole thing with a transparent material, put away his paints and walked off without giving his work a second glance. A Mr Marcuse, who was present along with other exhibitors,, expressed the feelings of all: 'There, that's masterly, he does not stop to look at his work; he knows it is done, and he's off'.

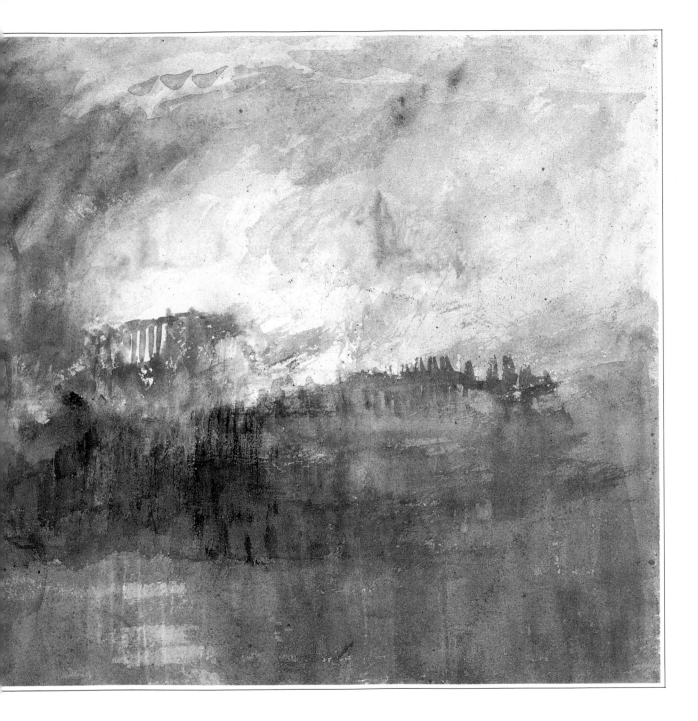

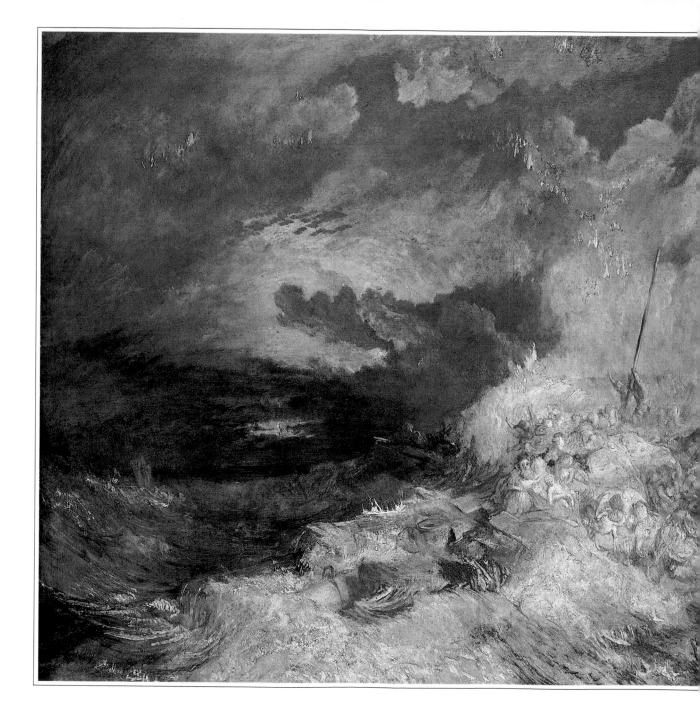

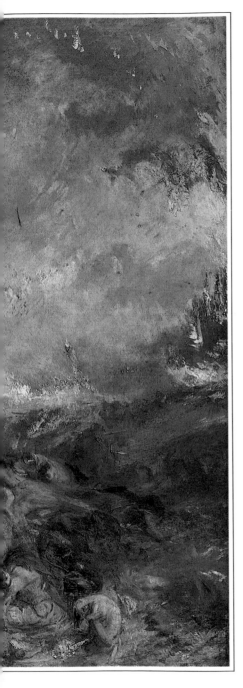

◁ **Fire at Sea** 1835

Oil on canvas

THE SUBJECT OF FIRE as a dramatic event was very much in Turner's mind after the devastating conflagration at the Houses of Parliament and may have given him the idea for a painting of a fire at sea. In this picture, the actual ship on fire is not seen but the intense blow and sparks on the right of the picture show where it is. The painting is unfinished, which suggests that Turner planned to work it up into one of his spectacular exhibition pictures which were causing his contemporaries such dismay. When it was received by the National Gallery in 1956 it received an inventory number without question.

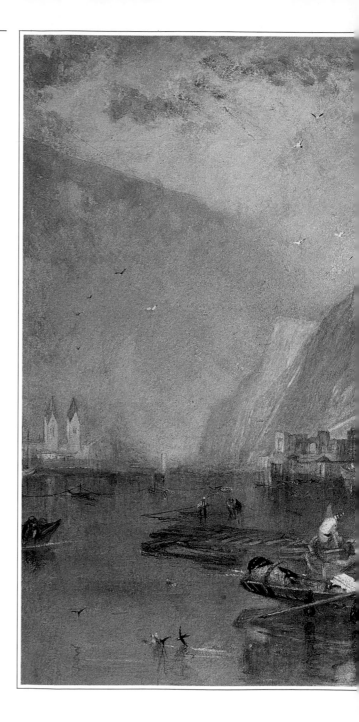

▷ **Ehrenbreitstein** 1835

Watercolour

WHEN TURNER FIRST made his
sketches of the Rhine romantic
notions about the early days of
the French Revolution were
still current. At
Ehrenbreitstein, near Coblenz,
a memorial had been erected
to the revolutionary General
Marceau who had been killed
at the siege of the city in 1796.
This gave Turner the theme
for the watercolour, produced
from sketches made during his
first visit. The noble theme
encouraged a sympathetic
review of the painting, which
the *Athenaeum* critic called a
truthful representation:
'Imagination and reality strive
for mastery in this noble
picture,' he wrote.

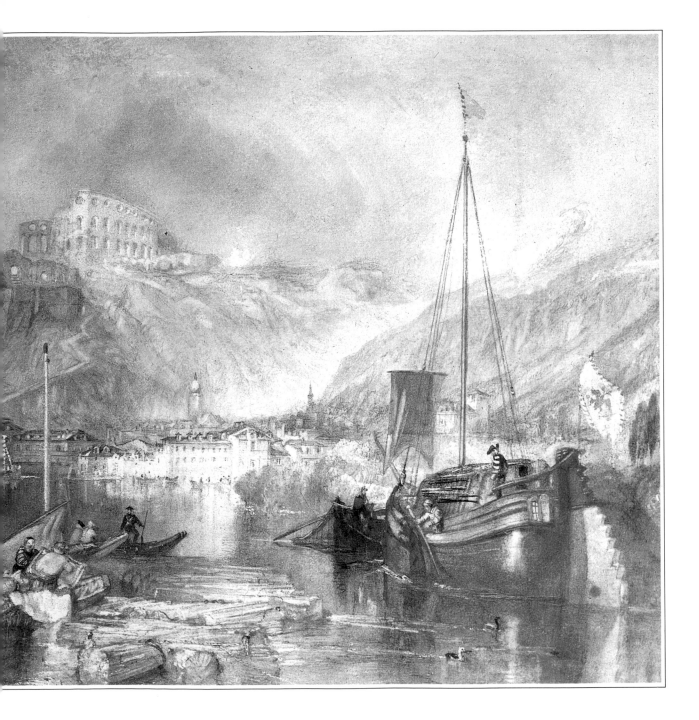

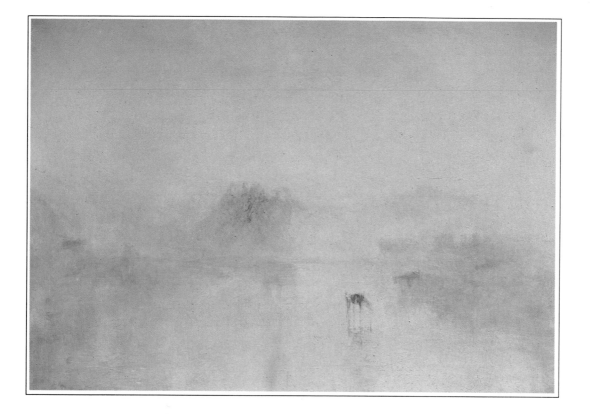

△ **Norham Castle: Sunrise** c.1835-40

Oil on canvas

NORHAM CASTLE on the River Tweed attracted Turner's attention as early as 1797, when he first sketched it. A watercolour which Turner exhibited in the 1798 Academy exhibition was a great success. Over the years, he did some 20 versions of the subject, in pencil, watercolour and oil. The engravers Charles Turner and William Miller also made prints of it for a wider public. Turner's first paintings of Norham were in dark tones, but as the years went by he painted it in a lighter manner so that the whole scene became dissolved in a finely coloured misty atmosphere. This beautiful oil is so finely toned that it looks like a watercolour.

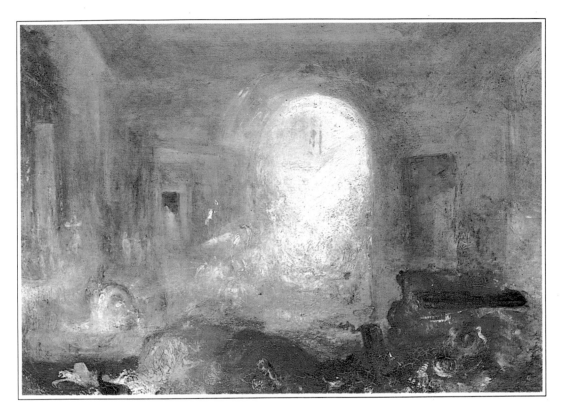

△ **Interior at Petworth** 1837

Oil on canvas

THIS IS A MYSTERIOUS painting, with a ghostly presence of objects – or perhaps people and even two small dogs – in a large room lit by the light filtering through an arch. It has been suggested by the critic and writer David Thomas that the painting may represent Turner's feelings on the death in 1837 of his patron, Lord Egremont. Certainly, there is a strong sense of desolation here. A more defined composition seems to have been painted over, so that the previously discernible objects or people have become wraiths scattered about the deserted room.

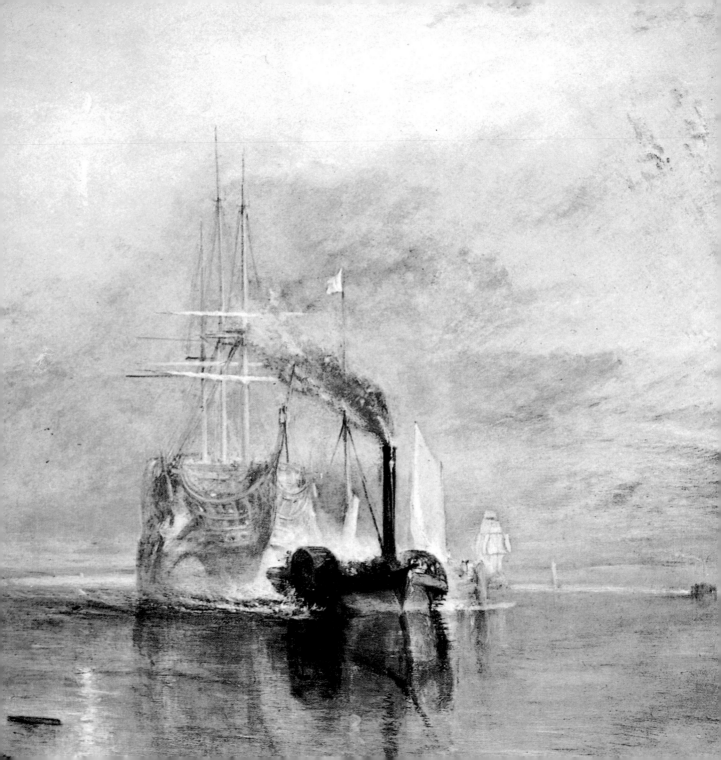

◁ **The Fighting *Téméraire* Tugged to her Last Berth to be Broken Up** 1838 1838-9

Oil on canvas

THE *Téméraire,* NAMED AFTER a French 98-gun ship captured at Lagos Bay in 1759, fought at the Battle of Trafalgar in 1805. The *Téméraire* was one of the last warships of its kind and when it went off to the breaker's yard it was a sad occasion for the whole nation. Turner portrays the *Téméraire* as a ghostly reminder of the days of sail, towed away by a steam tug which is shown clearly and forcibly. The setting sun and the rising moon, indicating the coming of night, also are symbolic of the passing of an age.

▷ **Tancarville on the Seine** c.1840

Watercolour and body colour scraped out

THE 10TH-CENTURY CASTLE of Tancarville was popular with 19th-century lovers of the picturesque. Today, it marks one end of the huge suspension bridge built over the Seine at exactly the point that Turner painted. He had planned several series of views of the rivers of France, turning his attention to the Seine in 1821, then again in 1829 and 1832. This picture of Tancarville, apparently executed some years after the 1832 visit, was based on colour studies done at the river. It indicates a return to the more romantic Claude-like approach of Turner's earlier years.

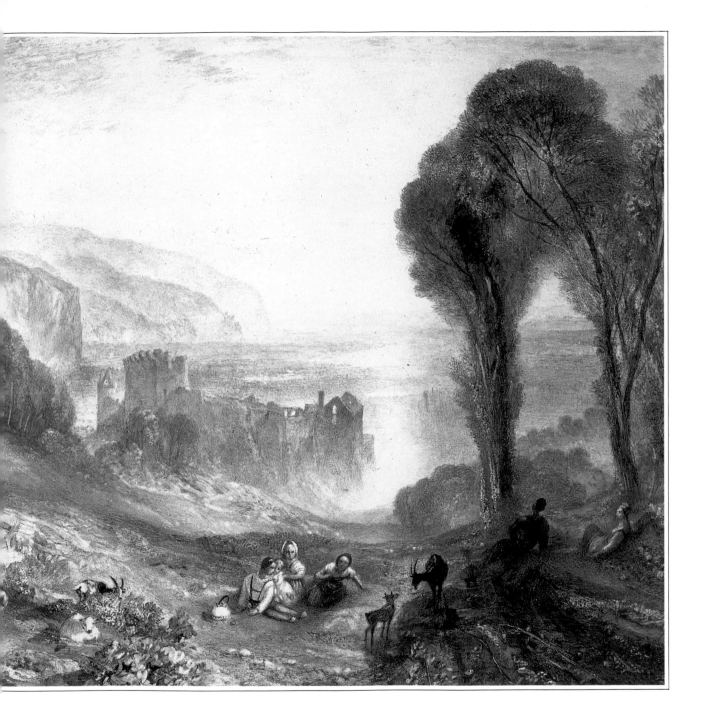

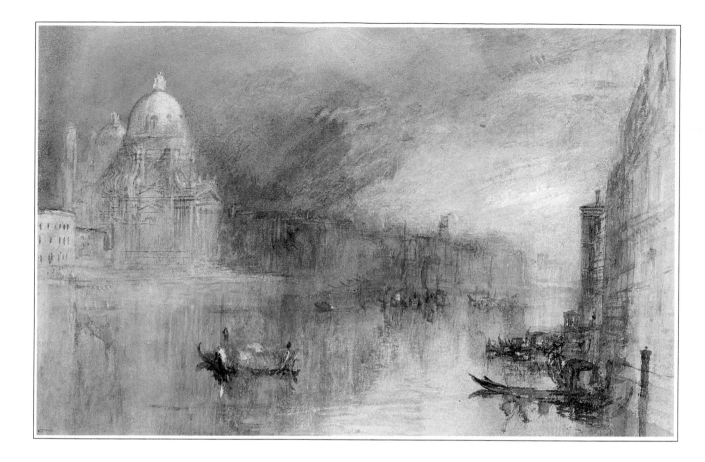

△ **Venice: Grand Canal with Sta Maria della Salute** 1840

Watercolour

TURNER'S VISIT to Venice in 1840 was one of the most prolific of all his periods of work in La Serenissima. He painted and sketched incessantly from his hotel room, in the streets and from gondolas which he hired for trips from St. Simeon to the lagoon along the Grand Canal. By this time, Turner's technique in watercolour had become very fine and rapid. He was able to do hundreds of sketches in a short period of time, each of them, even when unfinished, unsurpassed by the work of any other painter. The church of Sta Maria della Salute, built for the Venetian people by Baldassare Longhena in gratitude for deliverance from the plague of 1630, stands near the entrance to the lagoon and provided Turner with a subject for many pictures and drawings.

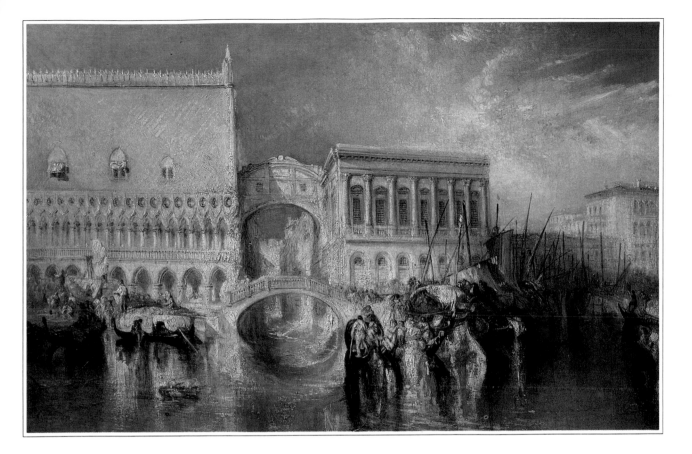

△ **Venice, the Bridge of Sighs** 1840

Oil on canvas

THE VENICE that Turner first visited in 1819 was a neglected, broken-spirited place which had lost all former greatness, having been conquered by Napoleon and then handed over to the Austrians after Napoleon's defeat. The glory of its architecture and setting was still there, however, and it inspired Turner to create a series of paintings which did much to restore the city's image and turn it into a tourist paradise. Following in the steps of Canaletto and Guardi, a number of English artists, including William Etty, Clarkson Stanfield and Bonington, painted Venice; none showed the passion and perception of Turner, with whom the conjunction of painting technique and subject was a marriage made in heaven.

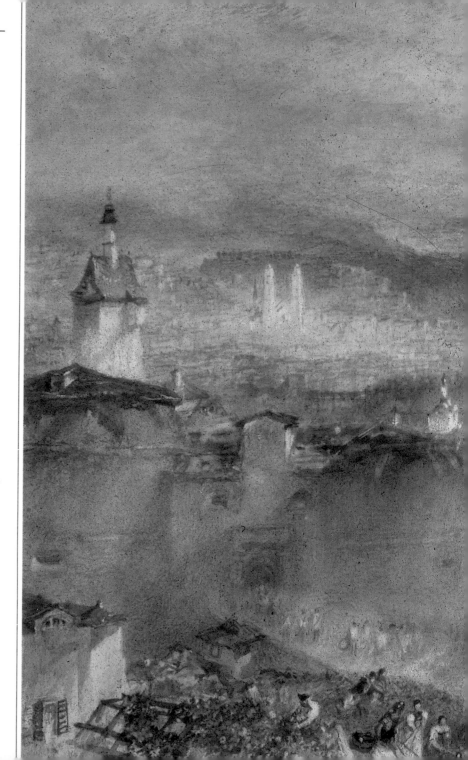

▷ **Zurich** 1842

Watercolour

TURNER'S SEVERAL VISITS to
Switzerland produced many
pictures of Swiss cities,
including Bellinzona,
Fribourg, Geneva, Lausanne,
Lucerne and Zurich.
Switzerland was a popular
destination for English
travellers, its romantic scenery
enhanced by its aura as a
cradle of liberty, so Turner
knew that pictures of
Switzerland would be popular.
When he visited Zurich it was
a small town of some 17,000
inhabitants and a market
centre lively with social
festivities. It was an
atmosphere which Turner
tried to transmit in this view
looking down the River
Limmat towards the Zurichsee.

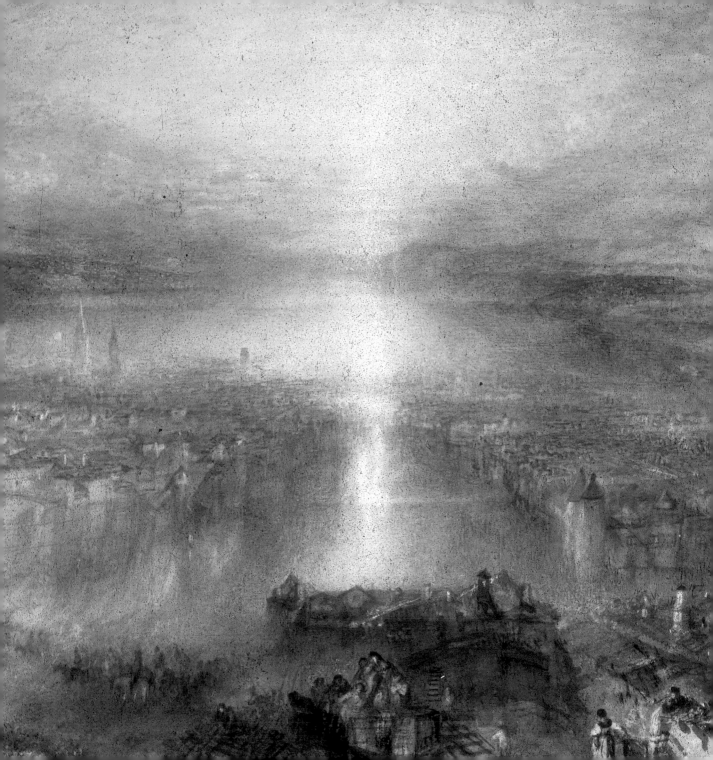

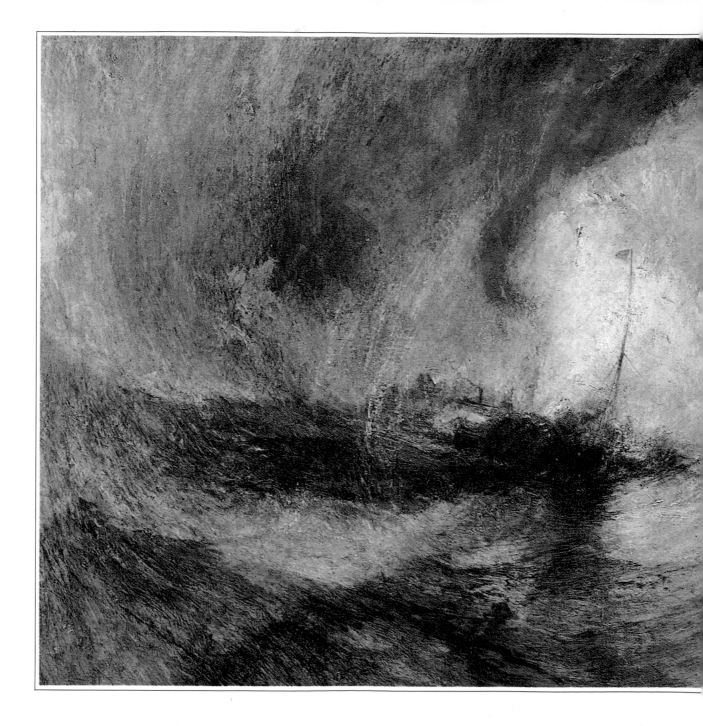

◁ **Snowstorm – Steamboat off a Harbour's Mouth
Making Signals in Shallow Water, and Going by the Lead.
The Author Was in This Storm on the Night the Ariel left
Harwich** 1842

Oil on canvas

DESPITE THE DETAILED title of this painting, which Turner claimed was the result of being tied to a mast to witness the storm, it is more of a painting of ideas than actuality. Here is Turner in his late period painting an epic of existence itself. Like van Gogh's *Night Sky* or Monet's lily-ponds, the subject is simply a means to expressing an idea about life in freely used paint. Little wonder that Turner's paintings were getting beyond the reach of even his most enthusiastic admirers and that the *Athenaeum* critic wrote: 'This gentleman has on former occasions chosen to paint with cream or chocolate, yolk of egg or currant jelly – here he uses a whole array of kitchen stuff.' According to Ruskin, another critic called the painting 'soapsuds and whitewash', which annoyed Turner so much that he spent an evening at Ruskin's father's house muttering 'Soapsuds and whitewash. I wonder what they think the sea is like?' Doubt has been thrown on Turner's story about being lashed to the mast because no ship called Ariel left Harwich on the night in question, though there was one called Fairy.

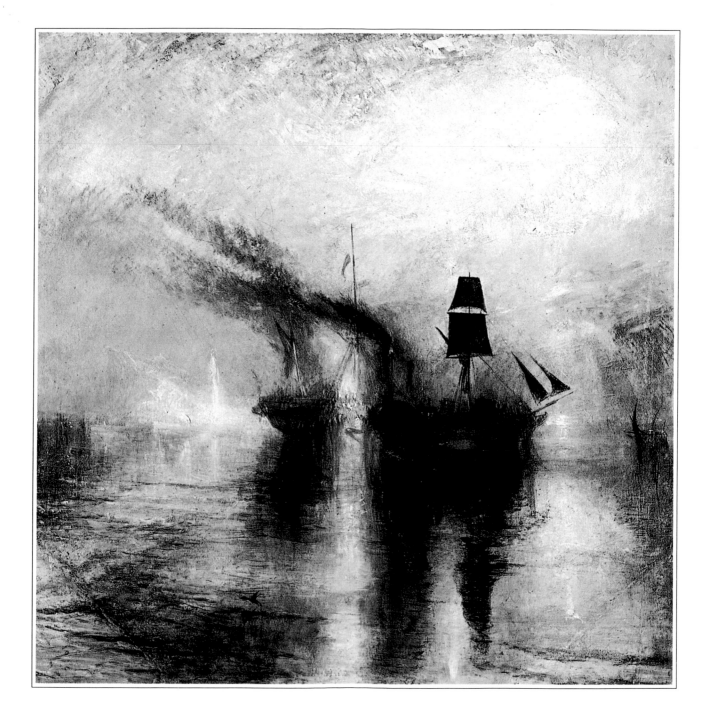

◁ **Peace – Burial at Sea** 1842

Oil on canvas

THE DEATH OF HIS FRIEND and painting rival Sir David Wilkie on a ship returning from the Middle East prompted Turner to paint this magnificent oil, and a companion piece *War, the Exile and the Rock Limpet* (a study of Napoleon). The memorial could hardly have been more splendid for this is Turner at his best, with a beautiful, evocative and unusual composition in which the surprising and uncompromising black sails shocked several critics. Clarkson Stanfield thought Turner was going a bit too far; Turner, who was becoming more and more autocratic and impatient of silly criticism, replied that if there was any blacker paint he would have used it. Even Ruskin, always a champion of Turner's work, was a little shocked. Turner had, in fact, reached the point where original thinkers and artists often find themselves: he had outstripped his generation.

Rain, Steam, and Speed – The Great Western Railway 1844

Oil on canvas

▷ *Overleaf pages 70-71*

TURNER ADMIRED MODERNITY, including trains and even owned shares in the Great Western Railway. It is unlikely he had anything other than artistic reasons for this picture, whose painterly qualities as well as Turner's usual liberties with actuality (where is the second railway line?) would probably not have been thought appropriate for a boardroom. Here, as the train speeds over Brunel's bridge at Maidenhead, Berkshire, Turner is glorifying the railways and the industrial age – the first major artist to do so – and depicting the rush of progress carrying humans forward at an ever-increasing pace. He makes the point about speed and the more natural rhythm of life before the Age of Steam by including a hare running scared before the onrushing train and a ploughman, in the right middle distance, who symbolizes the age-old relationship between man and the earth.

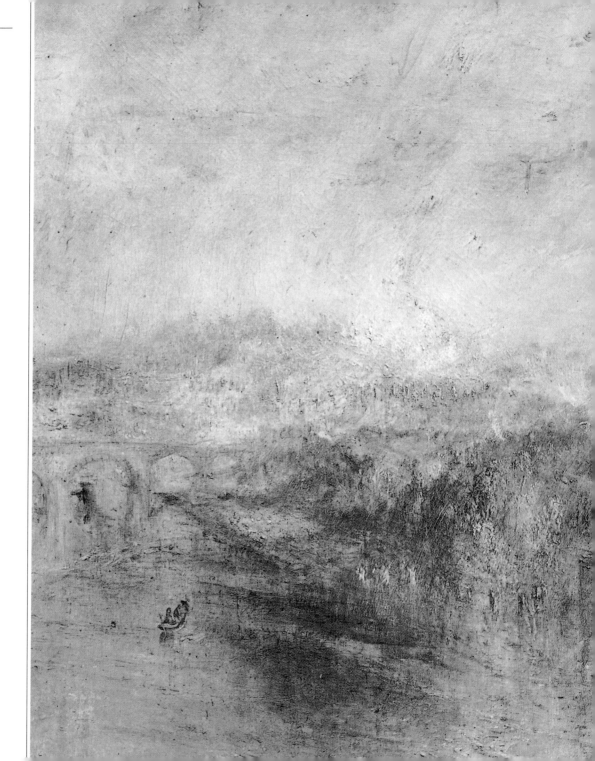

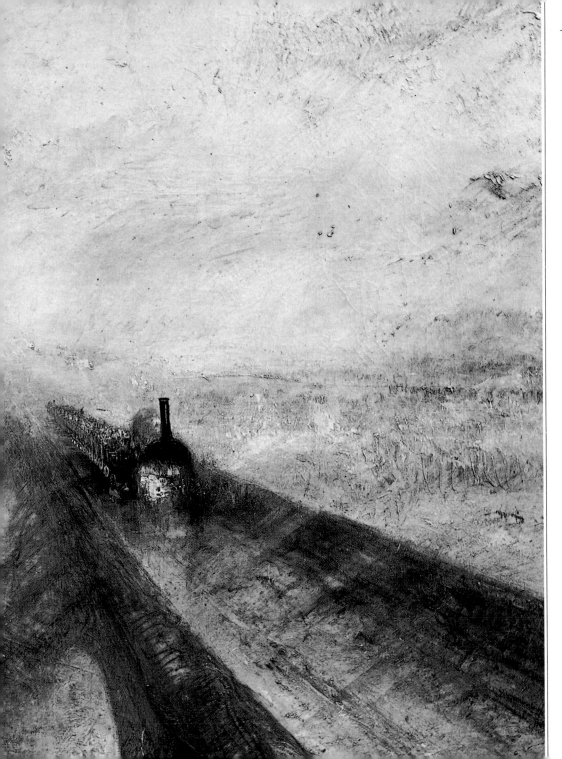

▷ Van Tromp Going About to Please His Masters 1844

Oil on canvas

TURNER, WHO IN A subtle way often managed to introduce a comment on topical events into his paintings, added to this title 'and gets a good wetting.' There are two theories as to what this means. One is that Van Tromp was pleasing his masters because he had accepted the intercession of William III in a disagreement he had with the Dutch admiral Ruyters, and had come to heel; the other is that Van Tromp had just defeated the English at Dungeness and was returning to announce his victory to his masters with, so legend goes, a broom tied to his mast to show that he was going to sweep the English from the seas.

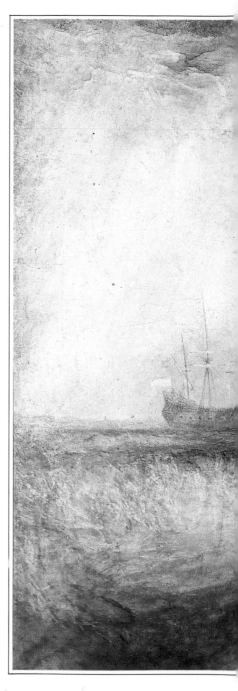

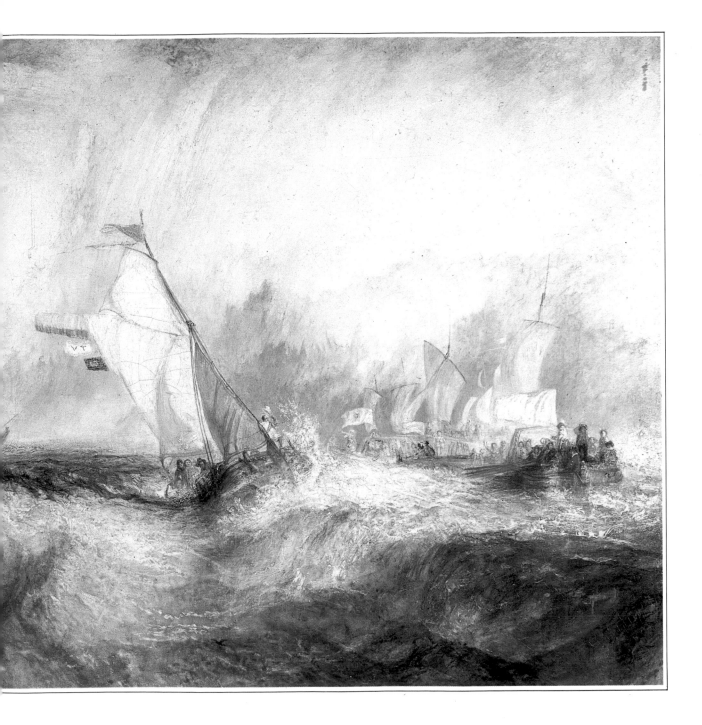

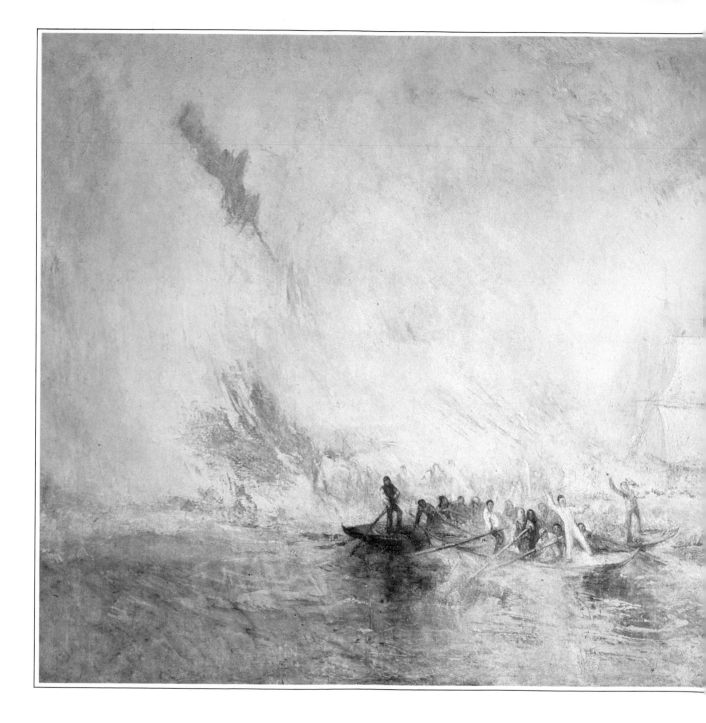

◁ **Whalers** c.1845

Oil on canvas

IN HIS LAST MAJOR appearance at the Royal Academy, Turner presented some of a series of paintings on the subject of whalers. Painted in cold grey tones and with ships and whales only faintly perceptible in the misty atmosphere, the scenes have a desolate air. In this one the wounded whale floats on the surface of the sea on the right as a boat full of triumphant whalers approaches. Their ship looms in the background in full sail like a pale ghost. Perhaps the slaughter of whales touched a chord in Turner's mind who at this stage of life was in a depressed condition, despite his achievements, because of his lack of success in communicating with the public through his more recent paintings.

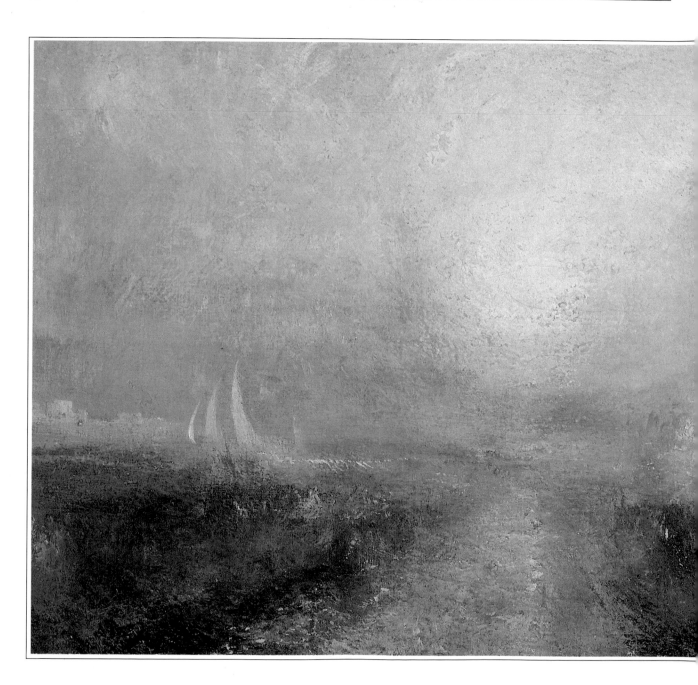

◁ **Yacht Approaching the Coast** c.1845-50

Oil on canvas

IN HIS LATER YEARS, Turner became increasingly drawn to painting pictures of the sea, perhaps because he saw it as a powerful embodiment of the forces of nature. This picture, with its swirling, vivid colour and ambiguous subject matter, seems to represent Turner's philosophy about the nature of life which had taken him a lifetime to arrive at. The yacht racing for harbour is no more than a fleeting shadow in the mysterious universe of the rest of the painting.

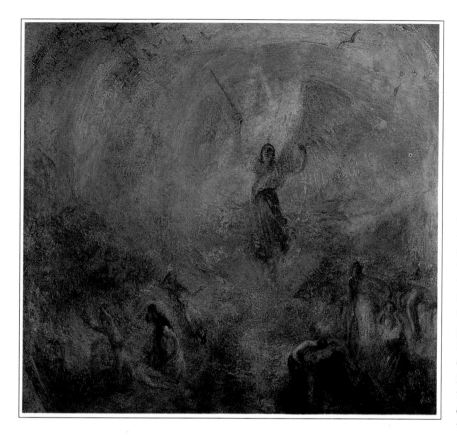

◁ **The Angel Standing in the Sun** 1846

Oil on canvas

TURNER BELIEVED the sun to be the centre of all life, like God himself, and in this painting God's messenger, the angel, stands bathed in the lifegiving rays of the life force. This reference is to the 19th chapter of Revelation: 'And I saw an angel standing in the sun; and he cried with a loud voice, saying to all the fowls that fly in the midst of heaven, Come and gather yourselves together into the supper of the great God; that ye may eat the flesh of kings, and the flesh of captains and the flesh of mighty men . . .' Turner's unconventional views did not endear him to a society that was becoming more and more complacent and he made little effort to curb his eccentricity.

ACKNOWLEDGEMENTS

The Publisher would like to thank the following for their kind permission to reproduce the paintings in this book:

Bridgeman Art Library, London /Agnew & Sons, London 11, 28, 37; /**British Library, London** 48; /**British Museum, London** 9, 18-19, 20, 22, 30, 31, 35, 36, 45, 60-61, 64-65; /**Bury Art Gallery and Museum, Lancs.** 54-55; /**Christie's, London** 12-13, 24, 25, 32-33; /**Fitzwilliam Museum, University of Cambridge** 47; /**Kenwood House, London** 16-17; /**National Gallery, London** 14-15, 26-27, 42-43, 44, 58-59, 70-71; /**Phillips, The International Fine Art Auctioneers** 62; /**Royal Holloway & Bedford New College, Surrey** 72-73; /**Tate Gallery, London** 8, 21, 23, 38-39, 40-41, 48-49, 50-51, 52-53, 56, 57, 63, 66-67, 68, 74-75, 76-77, 78; /**By Courtesy of the Board of Trustees of the V & A** 10, 29, 34, 46.